Any aesthetic connections the

reader may find between

the photographs and the poems in

this book are incidental.

The pictures do not illustrate

the poems, and the poems do not

comment on the pictures.

It is simply that two friends

who admire one another's work decided

to make a book together.

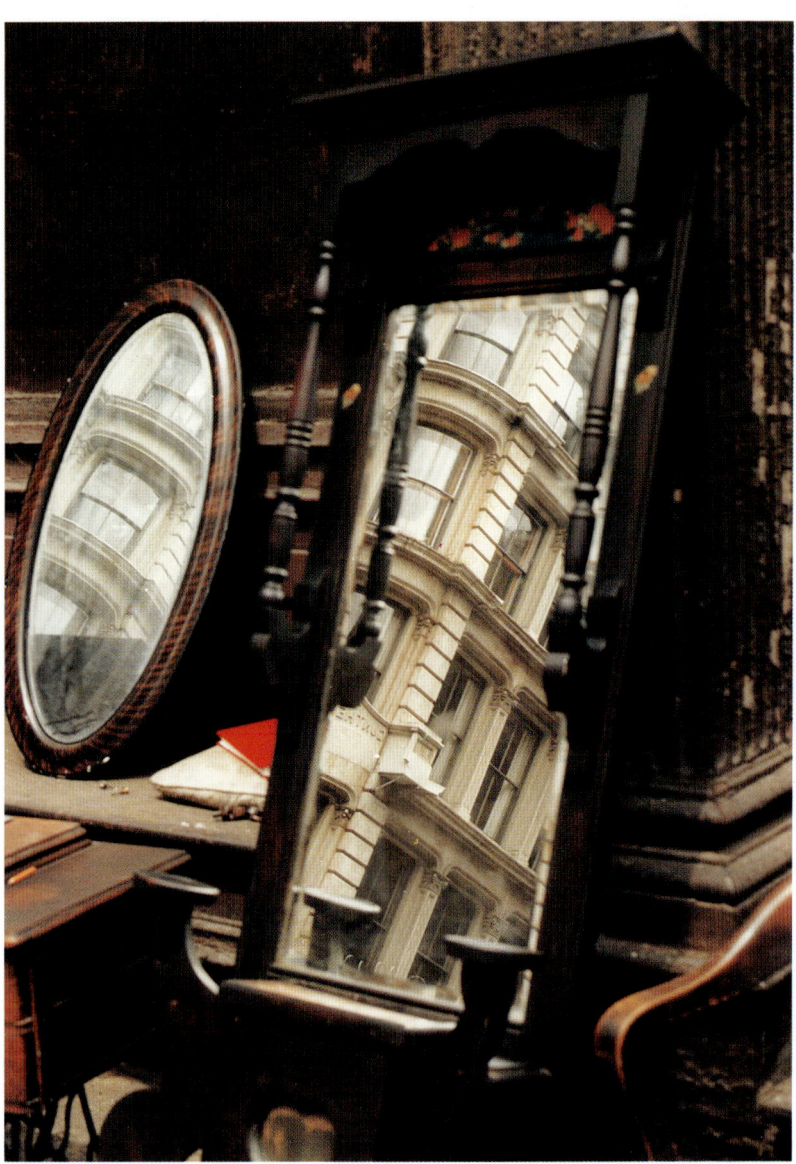

PHANTOMS

Poems by
James Laughlin

Photographs by
Virginia Schendler

A P E R T U R E

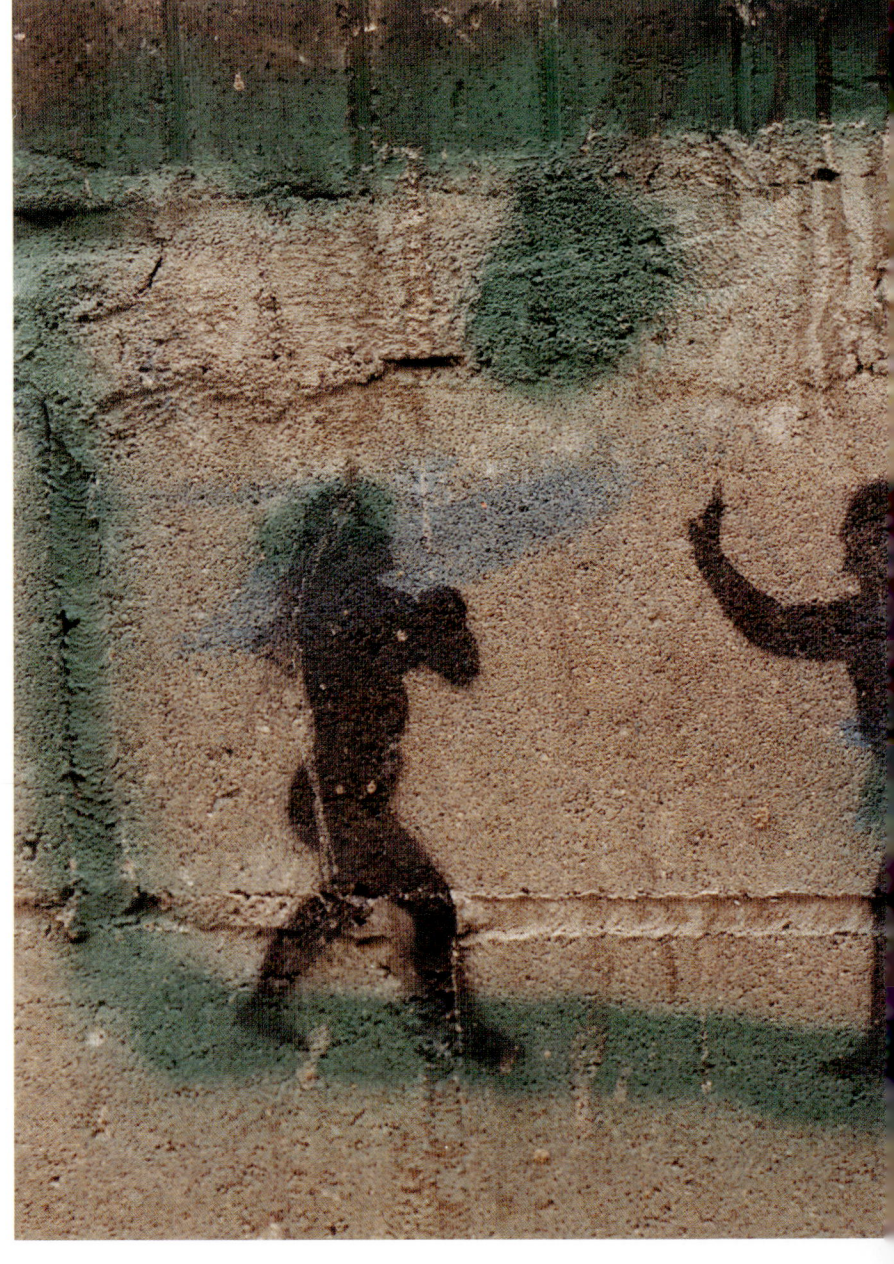

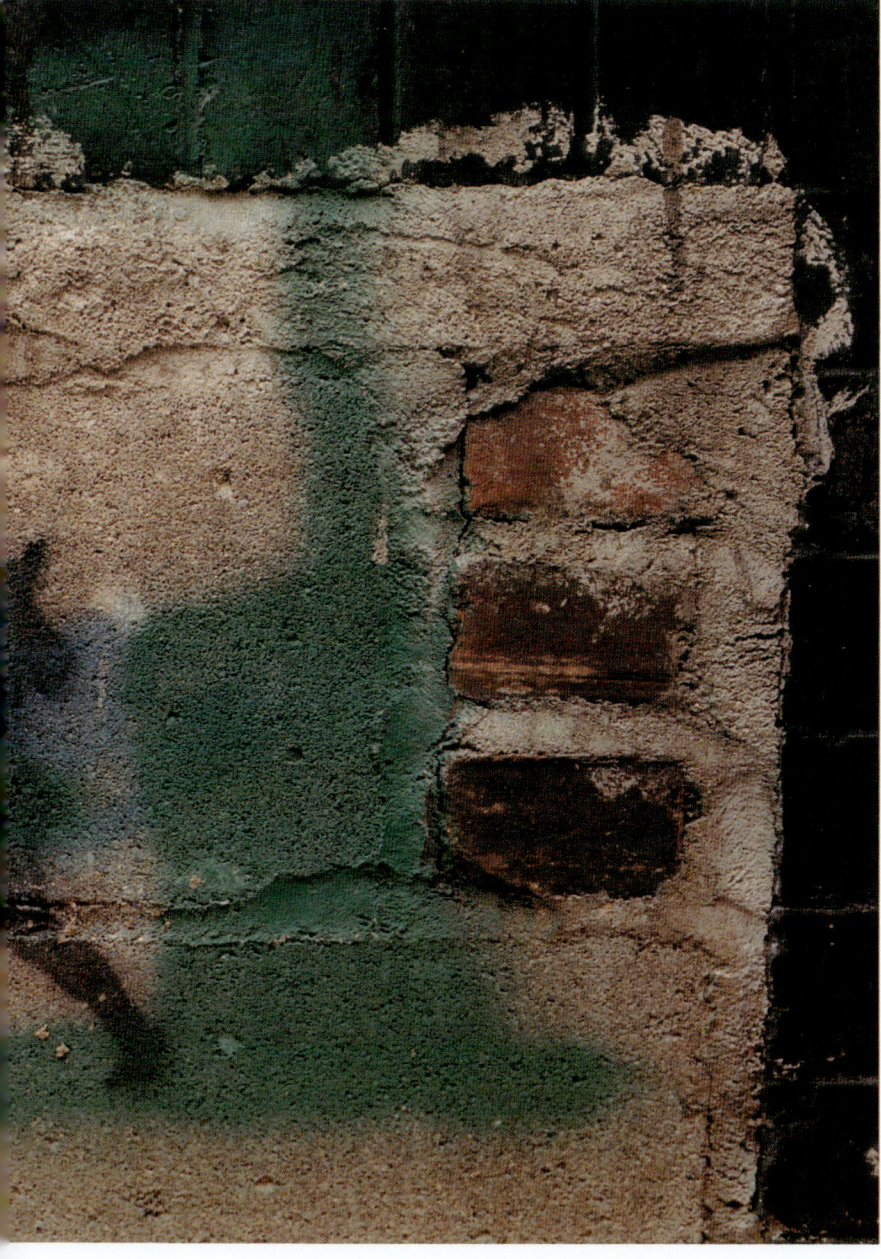

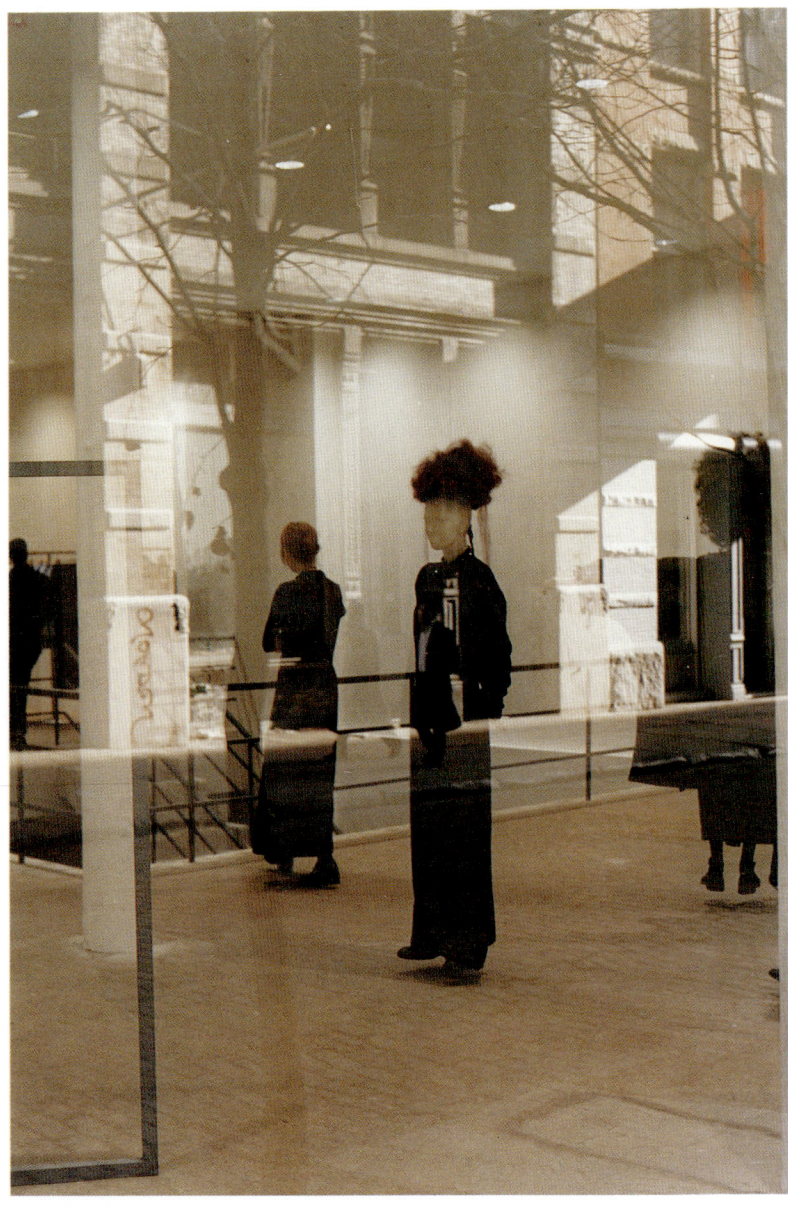

Along the Meadow Stream

The fluffy grasses on the edges
Of the stream hide my drifting line
And fly from the trout. Over the years
A deal of dreaming has drowned
In the limpid water. "Your mooning
Makes no knowledge," my grandfather
Used to tell me. "Let the fish be.
Get back to your books, lazy boy."
His voice has gone two lives away;
It stirs the water no longer along
The banks of the meadow stream.

Harry

When I was four my nurse
Gave me a boy-doll named Harry.
He was not a baby-doll,
He was a boy. He became
My best friend. He slept
Beside me in bed. I took him
Around with me. I rode him
On my tricycle. He sat on the
Table when I was eating.
The kids teased me about him,
But I didn't care. He was my pal.

When I was eight my mother
Snatched Harry and gave him
To the Salvation Army. I never
Saw him again. I don't know who
Got him. There has been a hole
In my heart ever since.

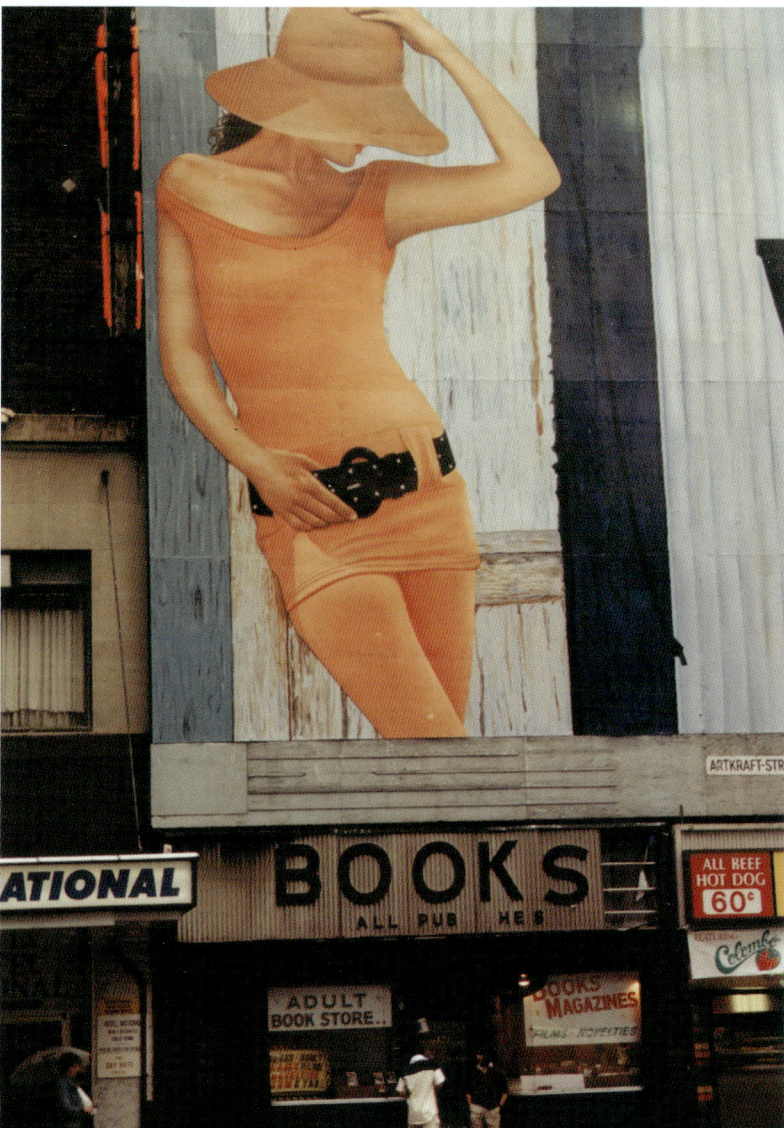

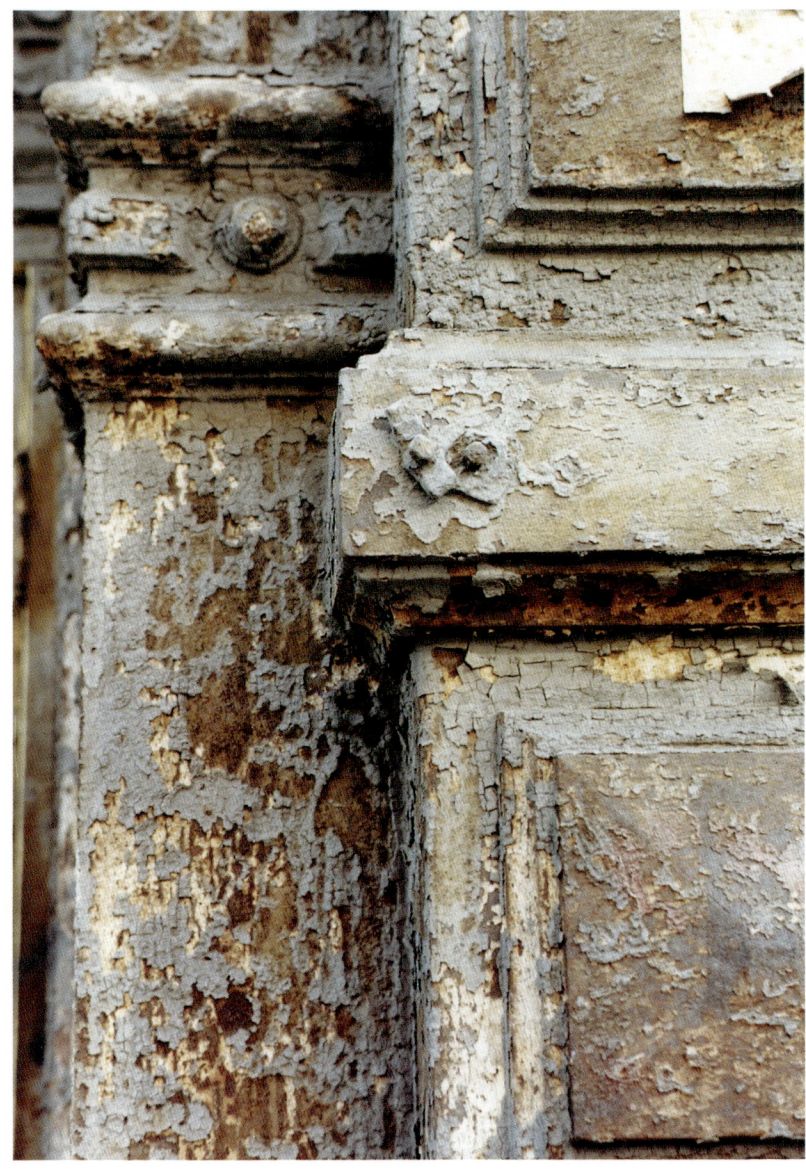

Motet: *Ave Verum Corpus*

My mother could not wait to go
To Jesus. Her poor, sad life
(Though she was money-rich)
Was made for that, to go to
Waiting Jesus.

Jesus loved her, that she knew,
There was no doubt about it,
Up there above, somewhere among
The twinkling stars, there was
A place of no more tears where
He was waiting for her, blood-
Stained palms and side, he
Was waiting.

Sweet Childhood

Why can't we pretend that
We're children who are
Playing with each other,
Not really understanding
What we're doing, but it's fun
It feels good and there is
An urgent curiosity to study
Each other's parts. Sweet childhood,
Happy time of innocence, come back
For us, bring back an hour
When everything was gentle and new.

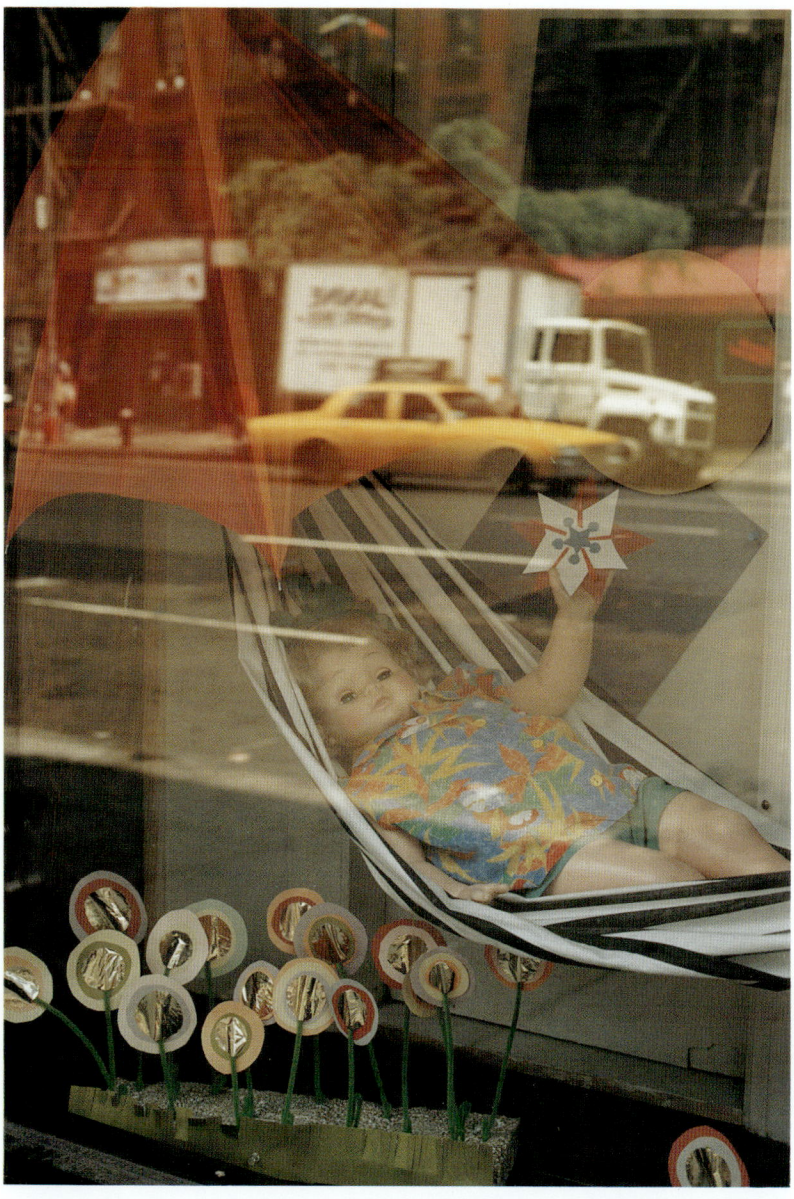

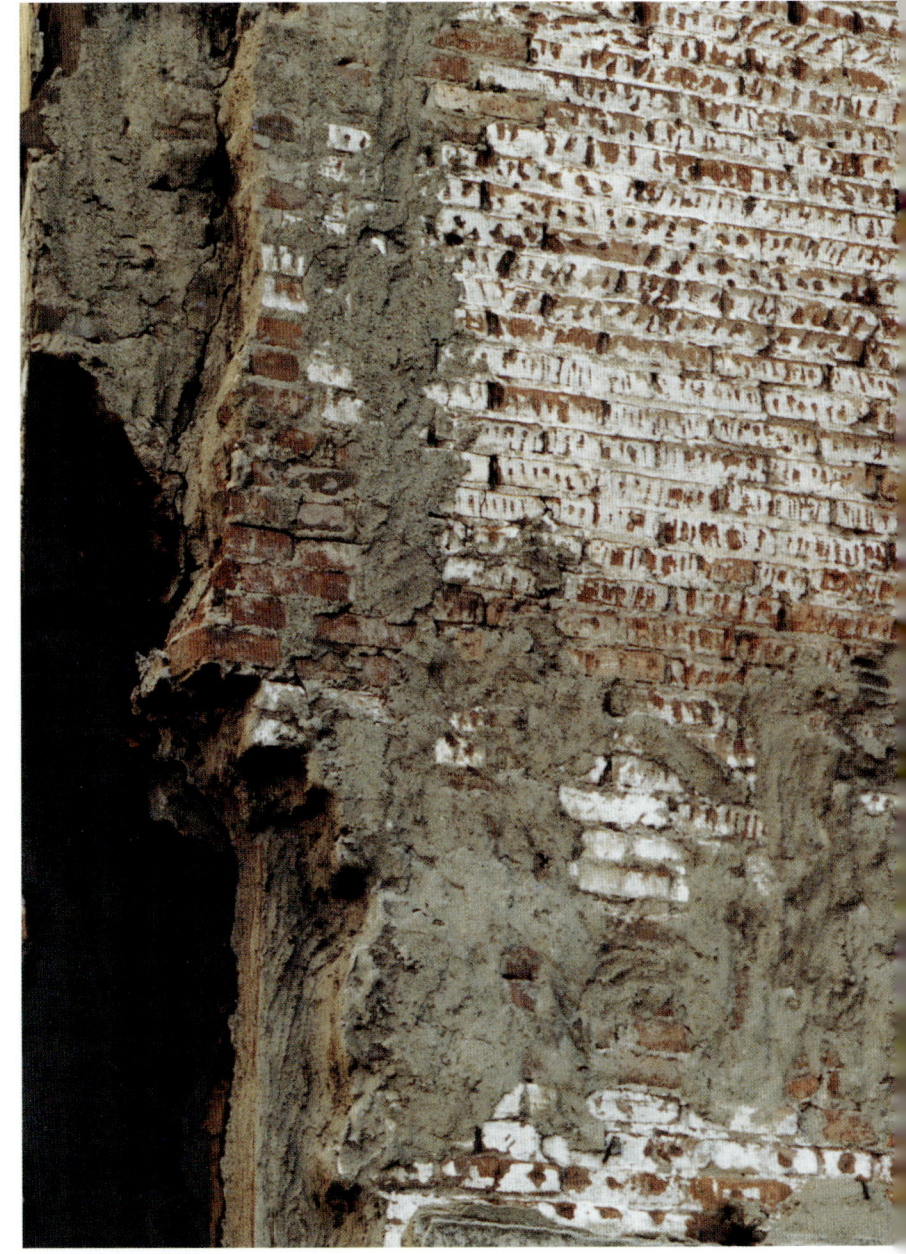

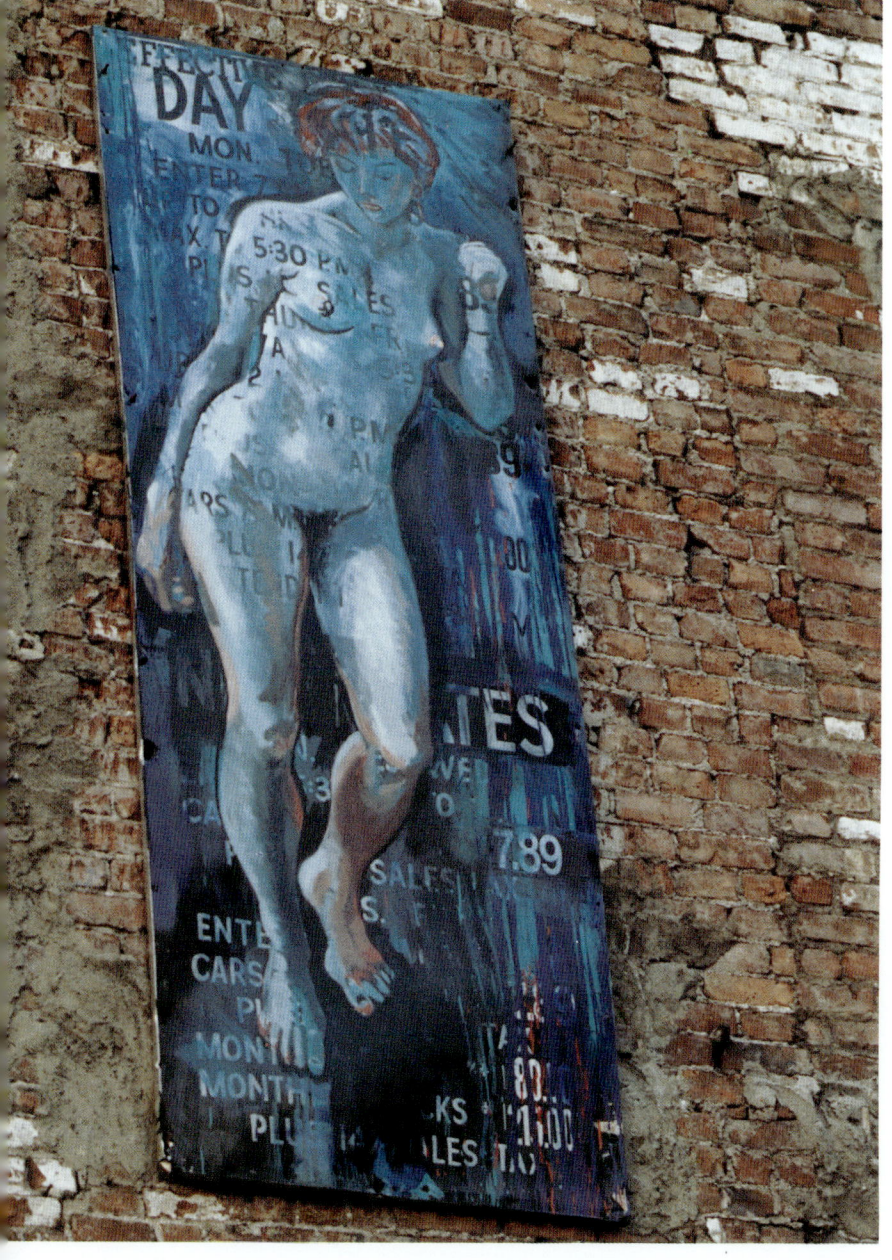

That Afternoon

when we were walking in the sunbright
 woods
and you were laughing so deliciously,
"*dulce ridentem*" said Horace of his
 girl Lalage
when suddenly I did what I'd been
 longing to do,
pulling you to me and touching for an
 instant
your sweet little breast, an impulse of
 courage,
and of course you sprang away,
but you did not reproach me, you put
 your arm
around my shoulders, as if to say
you were pleased by my avowal . . .

but the god was jealous of my
 happiness;
you haven't come to walk with me again.

Many Loves

She changes the way
she does her hair for
each new admirer if
she is to have many
loves she wants to be
a different person
for each one of them.

The Selfish One

She keeps her beauty for herself,
Eyes, lips, fair cheeks, dear breasts.
She guards all of them for herself.
She will not share them, or any part
 of them
With a lover, no matter how ardent
 he may be,
No matter how he woos her favor.

Is she not afraid, this self-regardant girl,
That some god will look down
And taking note of her greed,
Rape her away from among mortals
To work upon her his brutal passion
That will destroy her cherished
 loveliness.

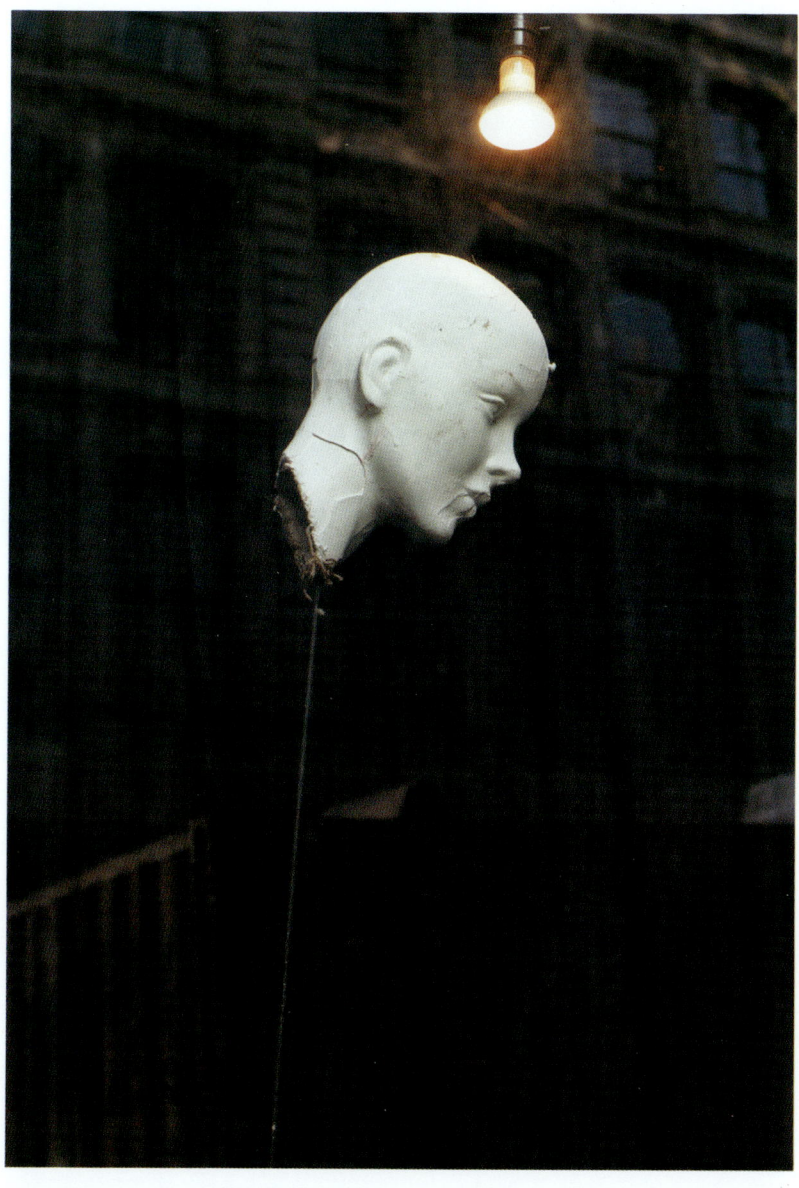

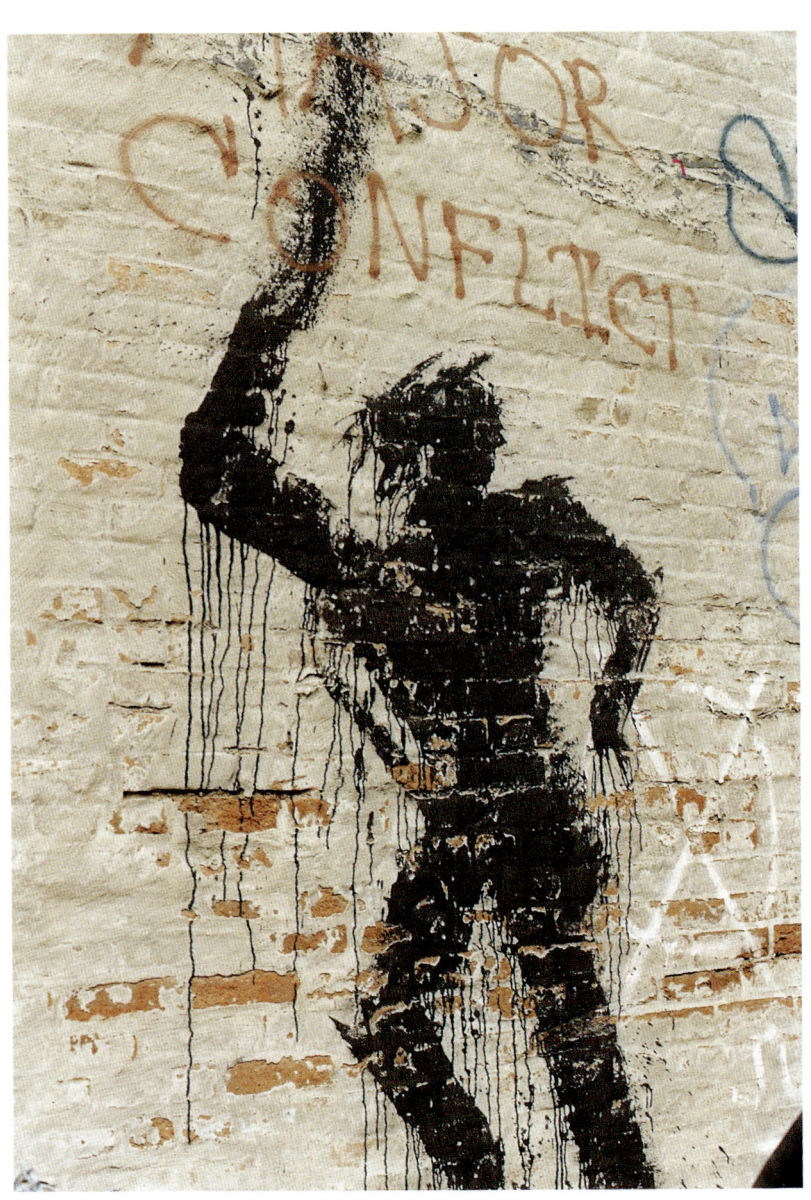

She Does Not Write

Though she must know her silence
Is a painful burden for me to bear
(*Un fardeau grave*, as the French
 would say)
When we said goodbye at the station
There were little tears on her cheeks
(*Des larmes de tendresse*).
But that was ten days ago
And she has not written
(*Aucun petit mot pour me dire
Qu'elle pense à moi*).
Is she already forgetting
What passed between us?

Jack Jigger

They call me Jack Jigger because
I'm entirely made of little pieces
Taken from other people (some are
Alive, some dead). If there were
An autopsy the coroner would have
A hard time identifying which bits
I was born with, which were really
Mine. I can hear him saying to his
Assistant: "There's a lot of foreign
Stuff in here, things I never ran
Across before." When I walk fast
I hear a kind of rubbing inside,
Like bits of paper rustling. That's
How it is, pieces of paper moving
Against each other. The doctor has
Tried every kind of coagulant.
But no use. He's given up on me.

Ophelia

She wanders in the meadow
Picking posies; she wanders
Among the willows singing
Sad little songs that have meaning
Only for her. She falls (or walks)
Into the stream, but she doesn't
Struggle in the water because
She imagines she's flying
up into the clouds, high up
Where there are no more troubles.

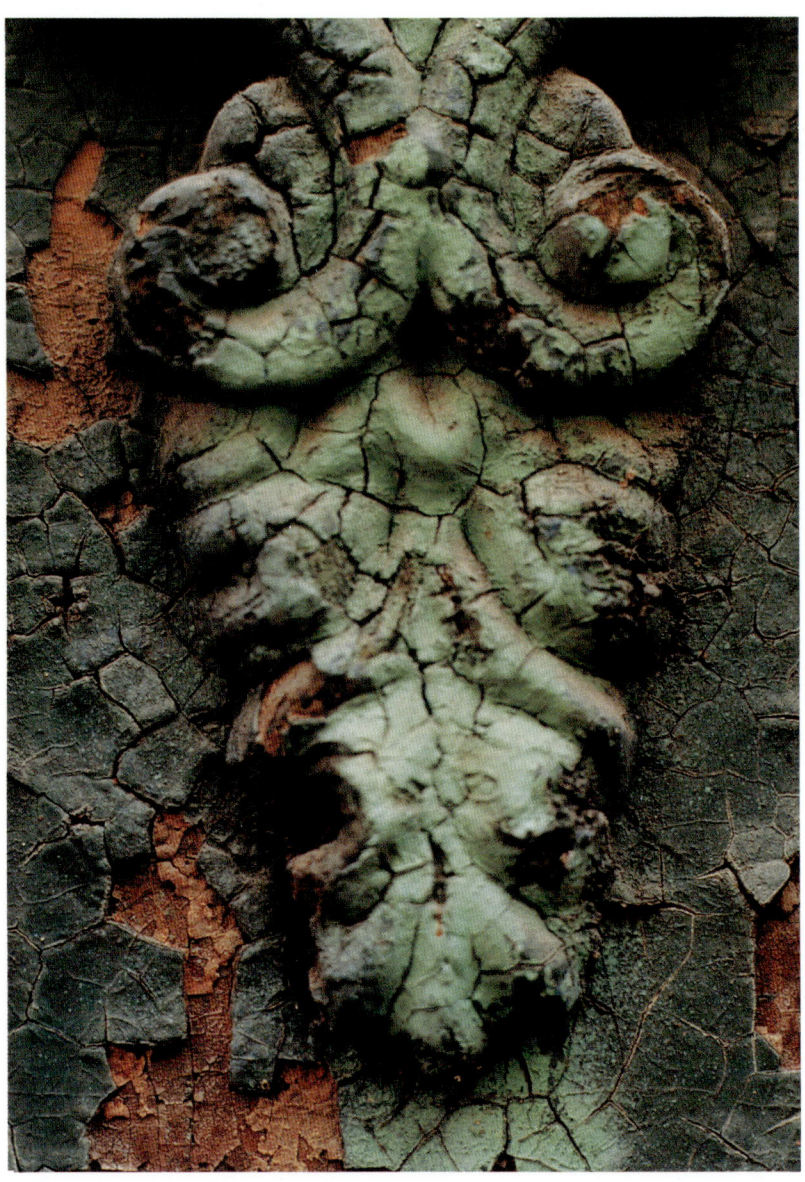

Anima Mea

After we had made love
a girl with big eyes and
warm breath started to
talk about my soul hush
I said hush and beware
if I have a soul it's
only a box of vanities
tied with frightened
pieces of string.

The Transients

She told me there had only
been three great loves in her life
but there were quite a few
transients, as she called them.
Don't misunderstand me, she said,
I've never been wild,
but you know how it is,
when you're young and going out
quite a bit, exploring life,
when a man gets insistent,
a nice enough man you like a little,
it's just too tiring to say no
because it means making a scene.

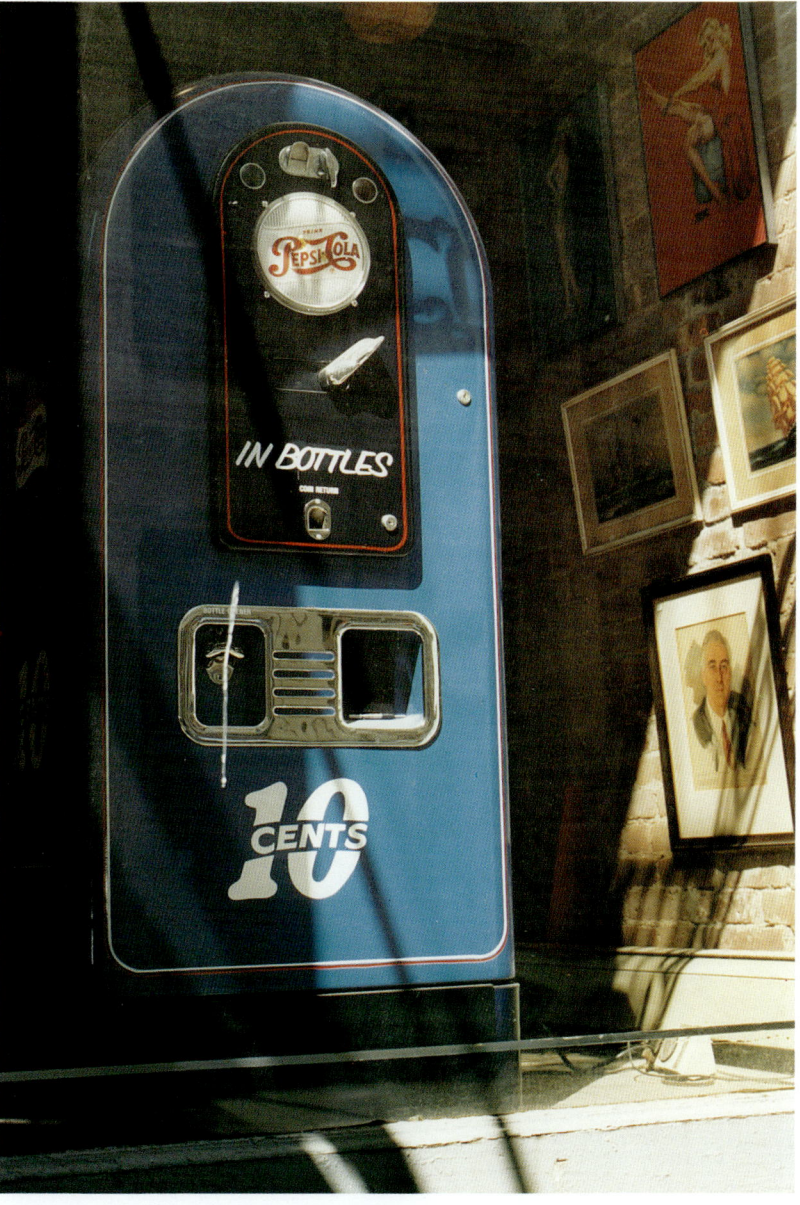

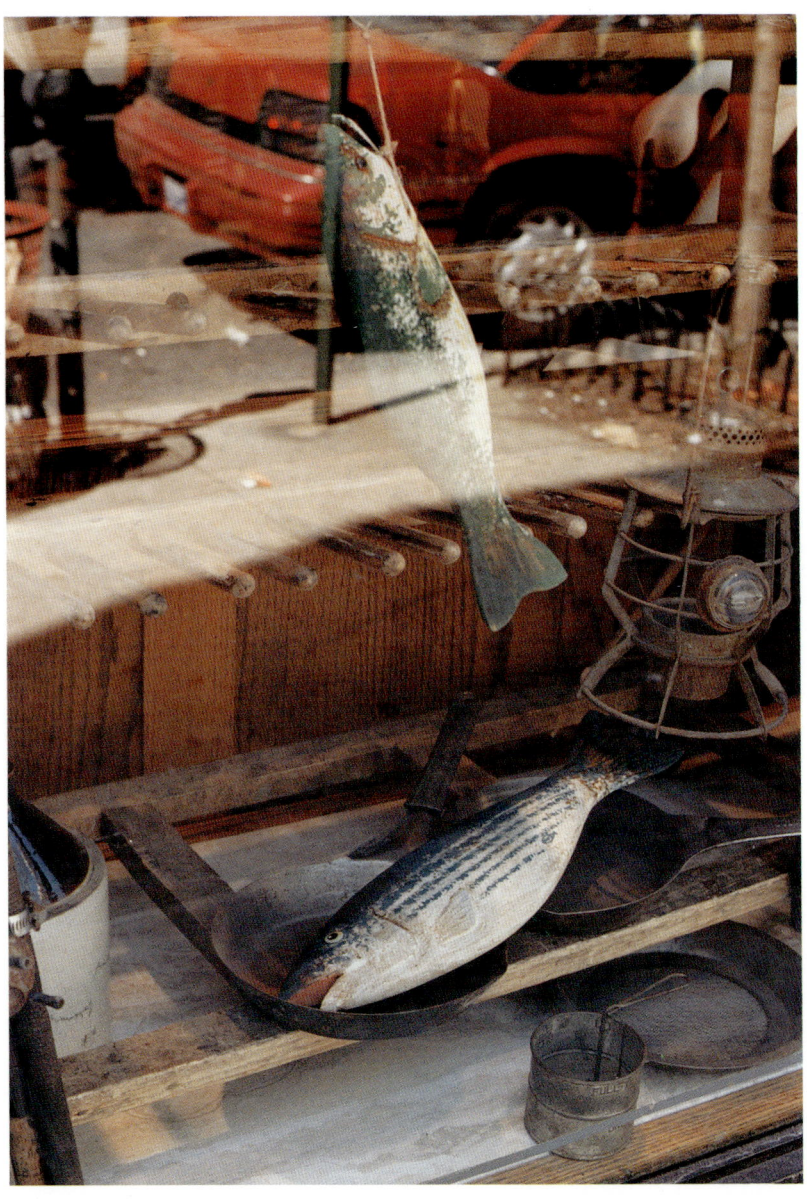

The Petition

They will say that you were never born,
That your beauty was never seen in any
 place or time.
They will say that we never loved.
Can I silence fools with a little rhyme?

Believe Me

There can be shadows in the dark
Not many can see them
But a lover can see them
As he waits for the beloved to join him
And a lover can hear
Even the fall of a naked foot
As the beloved approaches
He can hear the soft breathing
That is rising in expectation
As he stretches out his hand in the
 darkness
To welcome her to the place of love.

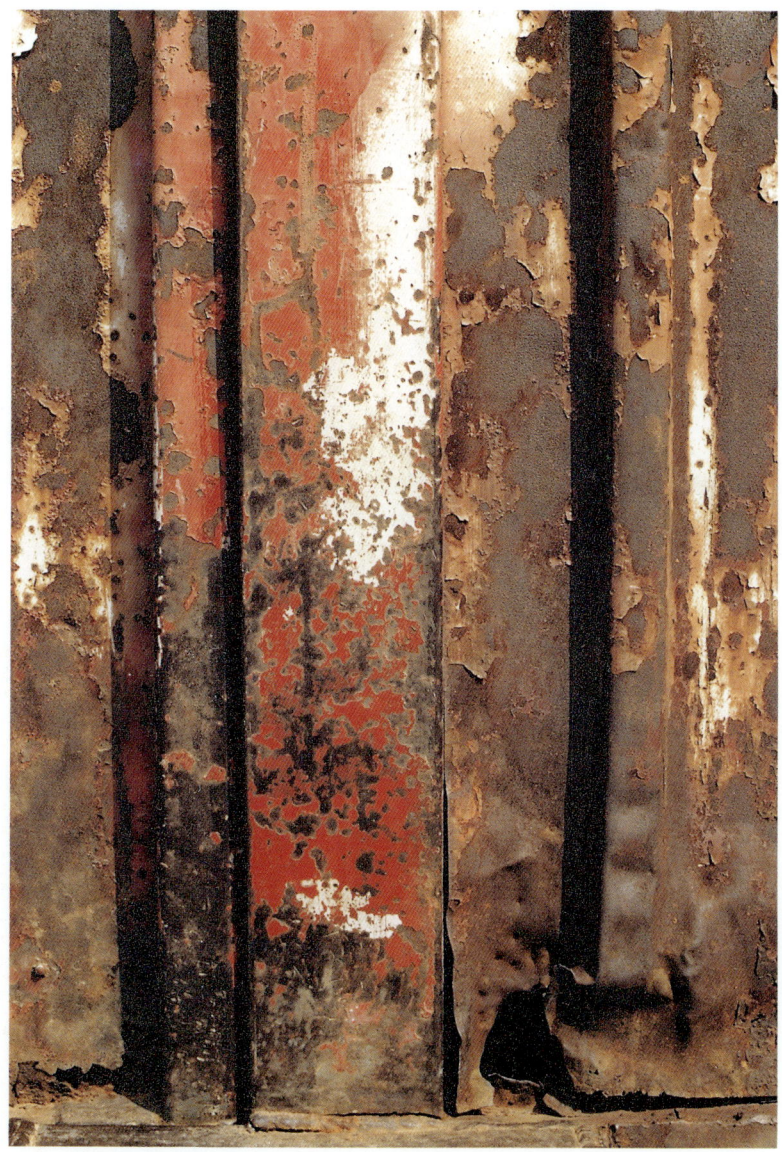

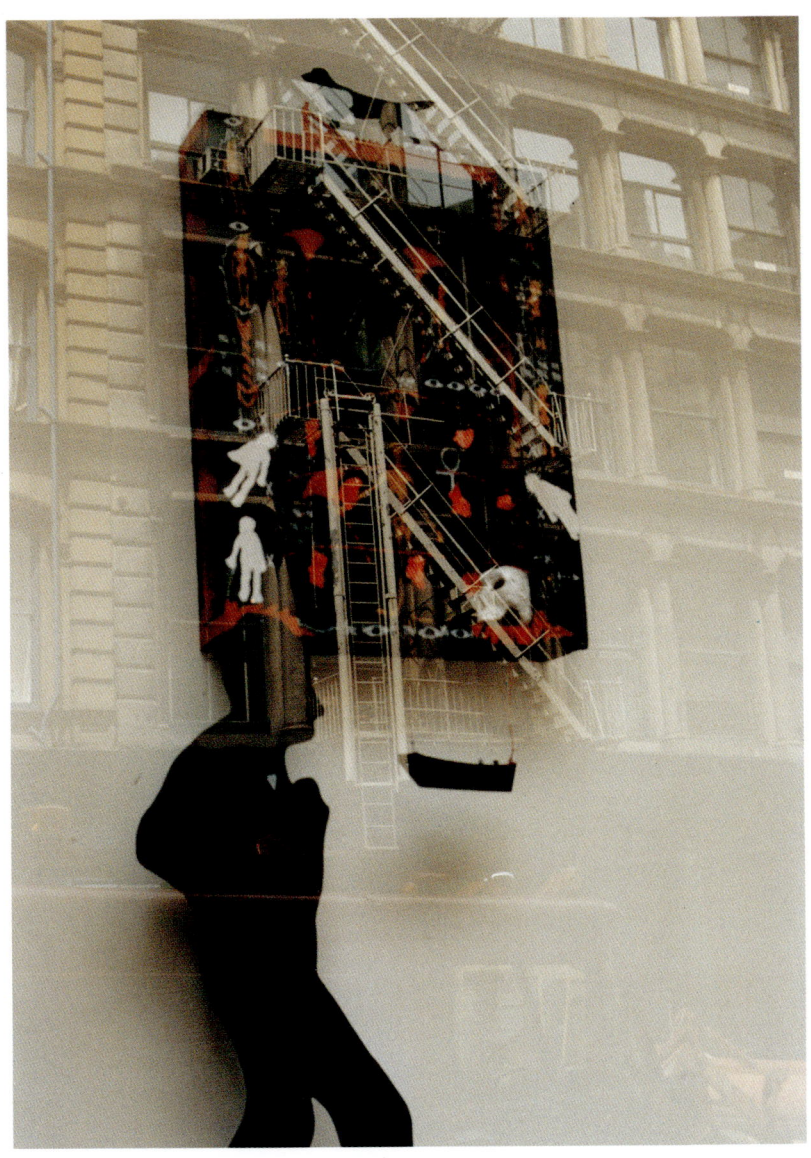

The Daze of Love

Comes sometimes from
the blaze of light
when an asteroid
passes us too near.

There is also
the softer radiance
when we are separated
and sink into sleep
thinking of each other.

The Enigma

Can two lovers ever name
The great secret
They want to tell each other?
They speak, they look, they touch
But the term eludes them.
No poet ever told it to them,
No singer sang it: the aleph,
The irrefutable mandala.

Old Men

Old men fall in love
With young girls readily.
They have dear memories they'd like
To relive while still they can.
Be kind to them, maidens.
The day may come when
You'll understand what it is
To need to recapture
The raptures of the past.

A Winter's Night

The outside, where the snow
Is softly and soundlessly
Falling (there is no wind
Tonight) has brought its quiet
Into the house that was noisy
All day with TV voices,
The telephone ringing,
And the happy shouts of children
Romping from room to room.
Now, except for me, sleep
Has taken over the house.
I bring the silence of the dark
Outside into it. I wrap that
Around my cares. Soon I too
Will be sleeping.

Die Begegnung

It was in a dark forest
Where one night I was lost
Donner und Blitz
 Erfüllung und Verlust
 Schmerzen und Wonne
 Gelächter und Tränen
I encountered a hooded figure
Who was my other self
He gave me his hand and fair words
And followed me back to this city
Where he has never left my side
 Sorge und Freude
 Einsicht und Zweifel
My other self, my constant companion.

The New Young Doctor

at the clinic is fresh
out of medical school
and hospital internship.
He's up to date on all
the new cures he reads
about in the journals.
Some of the old fogies
here in the village
won't go to him, but
I think he's great. At
my last check-up he
told me I'd probably
live to be a hundred
because I have such a
good pulse in my feet.

Now and Then

He falls asleep a lot,
Only cat naps but it's rude
And embarrassing when there's
 company.
He's sitting in his stuffed chair,
More or less attentive to the
 conversation,
Then suddenly he drops off.
"Where have you been, Gramps?"
His granddaughter asks him.
"Just on a trip," he tells her.
"Now and then I like
To take a little trip."

The Calendar of Fame

"Farewell, farewell, my beloved hands,"
Said Rachmaninoff on his deathbed:
And Joseph Hofmann, the great pianist,
Invented the windshield wiper
From watching his metronome.
Genius that I am, all that I can do
Is hit wrong keys on my typewriter.

The Secret Room

People forget (if they ever knew it)
That they hear their own voices
Not through their ears
But in their own throats
Is there an image as well
For every breath of sound?

Yes, there's an image
But it seldom can be seen.
It moves too rapidly
And does not linger,
It escapes the eye.

Yet nothing, sound or sight
Is entirely lost—every sensation
Every face or voice
Is stored in the hidden room.
At the back of the brain
Only the keeper of dreams
Has the key to that hidden room.

That Very Famous Poet

His rhymes splatter on the page
Like raindrops in a storm. It's
As easy as that. They require
No guiding intelligence. (Pound
said of Petrarch that he had an
Assistant to put in the adjectives;
It didn't matter where they came
In the line.)

It's a bit more complicated for him
When it comes to whole stanzas.
But he has the answer for that too.
There's a sink in his study. He
Just turns on the faucet and lets
It run till it slows to a drip.

To be sure he has to type the poems
Out or run them through his word
Processor. That can be difficult
When all he has to work with is
Squishy liquid, but he has some
Little pink sponges to soak up
The wet. No sweat. It's easy.

Coprophilus

a poet whose talent is
as small as his minus-

cule mentula has been
slandering me in the

taverns alleging that
my verses are stolen

from those of my friend
Catullus he misses the

mark I simply ridicule
the opinions of a man

(if he is a man) who
can only ejaculate if

he has dined on his
own foul excrement.

Homage to Fellini

FOUND LINES IN *8½*

Do you study what is printed
On chewing gum wrappers before
You throw them away? If you did
Perhaps you would have some
Knowledge to understand what
Life is about. Or if only every
Other word you write were the truth
Your time on the spinning ball
Would not have been totally wasted.
If I could answer your questions
I would, believe me, but since
I can't answer them, let there be
Dedication to silence. When will
The script be ready? When can we
Finally start shooting? Or is
There no film to be made?

So Little Time

We have so little time
To be born to the instant,
And it is the instant,
What happens in the instant,
That decides what matters
In the poem or in love.
Wait for the instant, and
When it comes seize it.
It may never come again.

—St. John Perse

The Music of Ideas

Reverberates in the poet's ear.
At times it is a gentle sound,
At times it thunders. Pound rhymed
Ideas in the "Cantos," a complexity
Of tones that elicits astonishment.
We smaller poets must be content
With lesser harmonies. Our little
Minds are incapable of the great
Organ fugues. Better to be silent?

Where is the Country

We were always searching for,
That happy country we read about
In books when we were young?
Once we thought we'd found it,
And for a time we visited there,
But then we knew we'd been deceived;
It was not the dreamed-of country.
Or had we just deceived ourselves?
In making the choice of each other
Had we destroyed the happy land?

His Problem

Was an excessive interest
In the life of language.
There was no place for the
Emotions in his existence.
He was passionately absorbed
In words, as much with words
Themselves as with what they
Were saying. More and more,
The words built a wall around him,
Shutting him off from those
He should have loved and
Those who wanted to love him.